D0822578

HOW TO DRAW

MODERN FLORALS

Alli Koch

Copyright © 2022 Alli Koch
Published by Paige Tate & Co.
An Imprint of Blue Star Press
PO Box 8835, Bend, OR 97708
contact@paigetate.com
www.paigetate.com

All rights reserved. No part of this publication
may be reproduced or transmitted in any form
or by any means, electronic or mechanical,
including photocopy, recording or any
information storage and retrieval system,
without permission in writing from the publisher.

Photography by Morgan Chidsey, A Sea of Love
Florals provided by Bows and Arrows Flowers
Copywriting and editing by Hannah Pressley

ISBN: 9781950968824
Printed in Colombia

10 9 8 7 6 5 4 3 2

*For myself I hold no preferences among flowers, so long as
they are wild, free, spontaneous.*

- Edward Abbey

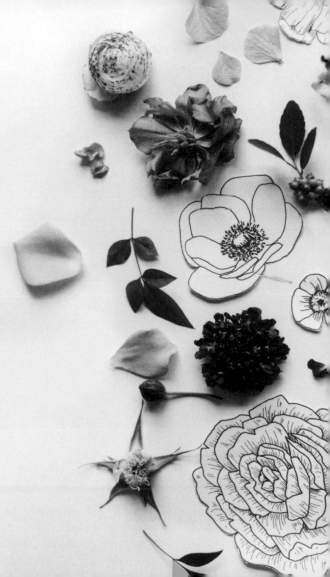

Hi! I'm Alli.

I'm a visual artist living in Dallas, Texas with my high school sweetheart, Landon, and our two cats. You can usually find me in one of two places: eating at Chick-Fil-A or working my magic in my art studio (probably with a large cup of Chick-Fil-A sweet tea in hand). I am the hands and heart behind Allikdesign, where I create my art and teach different skills from hand-lettering to custom illustrations to watercolors and more. My journey into the world of visual art started with a simple pen and paper and the curiosity to learn more about what I could create. My art and skills are all self-taught, and now I am ready to share what I have learned with you! Find more about me and my work at www.allikdesign.com

WHAT'S INSIDE

Inside you'll find step by step instructions for how to draw different flowers.

The beauty of drawing flowers is that no two flowers are the same in nature, so no two illustrations will be the same either. The thought that everything in nature is different and imperfect will hopefully make this process of sketching modern florals seem more approachable.

To make it even more approachable, each sketch is broken down into steps, and each step has specific instructions for where and how to start. You'll notice a dotted line in some of the illustrations which will show you exactly which line to start drawing first. Then the black lines are what to draw next, and the lighter gray lines are lines from steps you have already completed. Let's recap: dotted means start, black means continue, gray means already drawn.

We'll start with the most basic outline of the most simple flower to draw and work our way up. You'll see a pattern in the steps, starting with the center of the flower, then adding petals, and finalizing it with details to add depth and dimension. You may be drawing different angles and views of flowers, but the steps will always show you how.

Just remember, nature isn't always perfect, so you don't have to be either! By the end of this book, you'll have knowledge and practice you can take with you after you've turned the final page.

I can't wait for you to get started. I wish I could be with you every step of the way to see your progress and cheer you on. Since I can't hand deliver each book or sit with you and sketch alongside, let's use the hashtag #modernflorals101 to stay connected! Post your progress, ask any questions, and be confident in your creativity!

#modernflorals101

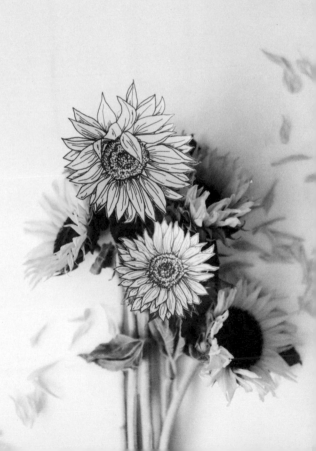

TOOLS

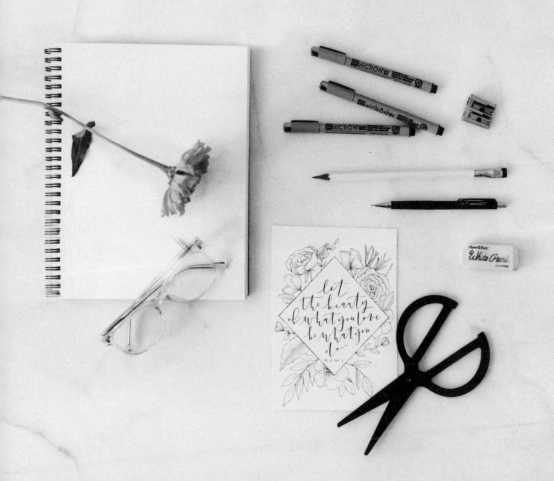

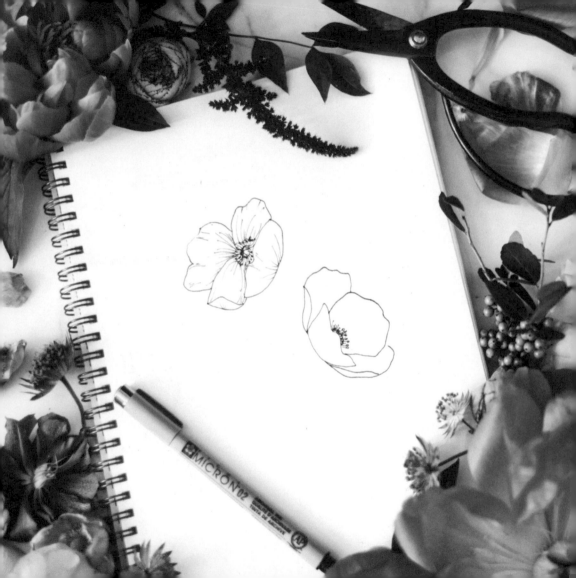

All you really need to get started is something to draw with and something to draw on.
And they don't have to be anything fancy.

I always recommend that people start their sketches in pencil so that they can erase or edit any mistakes along the way. You don't have to have a special sketching pencil. Any pencil will do. I typically use a .7 lead mechanical pencil for its finer point and the ease of replenishing its lead. An eraser is always good to have too. I normally use the classic Paper Mate Pink Pearl Erasers. If you want something more heavy duty, then I suggest the Tombow MONO Sand Eraser because it erases pencil and pen.

Once the initial sketch is made with pencil, you can move on to retracing your design in pen. Micron pens are the best and my favorite. I use these pens every day, whether I am writing in my journal, drawing flowers, or simply jotting down a to-do list in my planner. Micron pens come in a variety of sizes, several of which you will need to create the different line weights and shapes for your florals. I suggest micron pens size .005, .01 and .02 for the designs you'll learn in this book.

When it comes to paper, you can draw on anything. I've been known to sketch floral designs on a napkin while out with friends, or even on my arm if there is nothing else around. I encourage everyone to practice drawing their floral designs whenever they have something to draw on. Much of my success in art today is due to the fact that I have been constantly doodling and sketching and tracing and drawing wherever and whenever I can. So I encourage you to do the same!

If you start feeling confident in your designs and are ready to take them to the next level by uploading them to your computer or printing them, then you'll want to use a special type of paper called marker bond paper. This paper is semi-transparent with a unique texture that will prevent the ink from bleeding. Marker bond paper will give you the best result for scanning, printing and sharing your cool new designs!

The last and perhaps most important tool you'll need is inspiration. This shouldn't be too difficult seeing as inspiration may already be all around you! From actual flowers growing in your front yard to florists in your town or on Instagram, great inspiration is around every corner!

BASICS

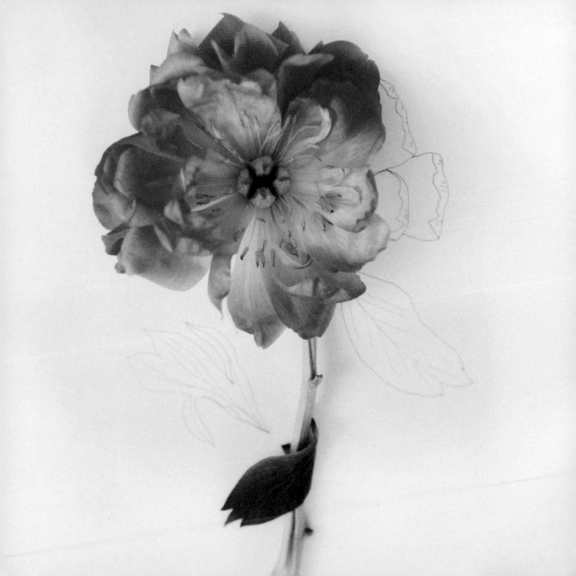

Understanding the basic elements and shapes of a flower will help us break down these "complex" illustrations. I want to show you that while the final illustration may look complex, each design is actually made up of simple shapes that you already know how to draw!

First, it's important that we break down the basic elements of what we will be drawing before we actually draw it. Knowing the basic anatomy of a flower will help you to better understand the illustrations you will be designing.

A flower has four basic parts: the pistil, the stamen, the petals, and the sepals. The pistil is found at the very center of the flower. The pistil is often a small, circular shape with an extension from its center that is called the stigma. This is an important part of drawing a flower because it is usually the first thing we will draw. Another part of the flower found towards the center is the stamen. For each flower that we draw, the stamen may look different. The center of a flower is crucial in terms of identifying that flower, similar to the way a thumb print can reveal the identity of a human. The most recognizable part of the flower to the human eye is the petals. The petals are the colorful part of the flower that come in a number of shapes and sizes. Finally, the sepals are like leaves that appear at the base of the flower and attach to the stem. You may not see any sepals in the beginning stages of drawing until we start illustrating bouquets.

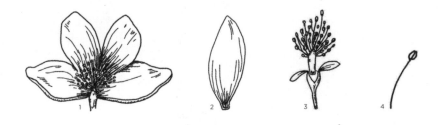

1. half part of a flower 2. petal 3. stamen and sepals 4. stamen

Now that you know exactly *what* you will be drawing, it's time to look at *how you* will be drawing it. Keep in mind that anyone (yes anyone!) can do this. Real or certified art skills are not required. The skills you do need are the ability to draw lines and the ability to draw letters, specifically an 'S' and a 'C.' I'm already confident that you have those two skills, so I know that you can do this!

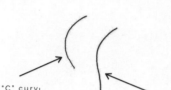

The main shapes you'll be making for these modern florals are called 'S-Curves' and 'C-Curves.' These curves are exactly what they sound and look like – the curves in the letters 'S' and 'C.' Each floral illustration is really just a number of 'S-Curves' and 'C-Curves' put together.

These curves are not only used to create the basic outline of the flower but are also used to give shape and definition to the flat image you have just created. By using curved lines, you can create shadows on certain parts of your flower that will bring your flower to life. In the art world, we call this line shading. The closer the lines are together, the darker the shadow; the more spread out the lines, the lighter the shadow.

The trick to remember here is that to effectively give shape to your flower, your shading must follow the same direction as the lines and curves of the part of the flower you are shading. You can't create definition using straight lines, and you can't create good definition using lines that are curved in the opposite direction of the part of the flower they are beside. To make your petals look curved, the curves of your shading have to curve with the outer curve of the petal.

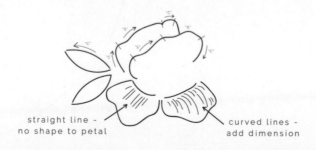

straight line -
no shape to petal

curved lines -
add dimension

FLORALS

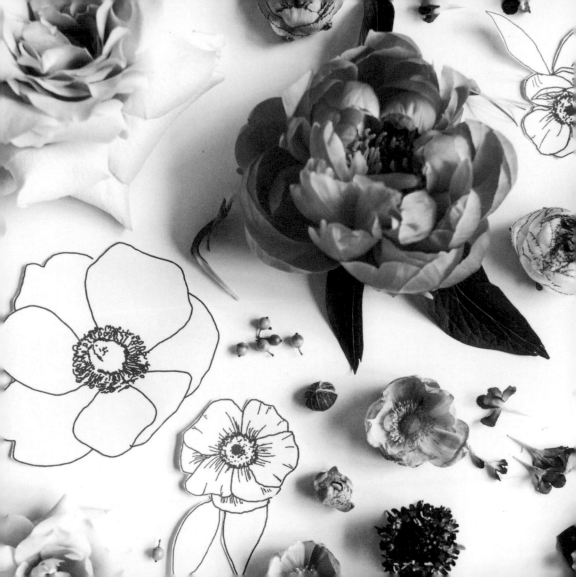

DAISY

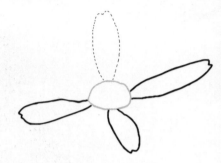

1

The daisy is the flower that everyone used to doodle in their notes at school. It's the flower of "He loves me or he loves me not." It's one of the most basic flowers to draw, so that's why we're starting with it first. Begin your daisy by drawing a small circle or oval.

2

Next, draw four petals on the four main quadrants of the flower, starting with a petal at the very top. This will help you with the placement of your petals as well as help you create more shape and depth later. The petals of a daisy are long ovals with very small dips at the edges of the petals.

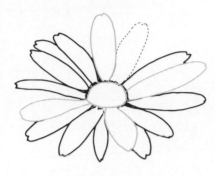

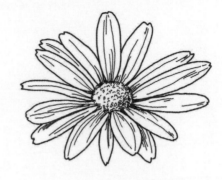

3	4

Continue to fill in the empty space around the center of the daisy with more oval-shaped petals. Some petals may not fit, so you may wish to draw some of the petals behind others to show that they are overlapping. Remember, the outer edges of the petals should not be straight lines. They should be curved and imperfect.

To give your daisy more shape and definition, use long c-curves that follow the curve of the petals to give them shape and short lines that are closer together at the center of the flower to give it depth. Also, make multiple small, upside down c-curves on the center circle. There should be more of these towards the bottom edge of the flower, which will create a shadow to add shape to the center of your daisy.

PRACTICE

DAISY

TULIP

1

If you glance at the final illustration, you'll notice that you'll be drawing a pair of tulips. We'll start with the tulip bud on the left first, and then transition to drawing the second tulip bud on the right. Begin by drawing the two main petals of the tulip on the left. Draw one petal in front, and the other behind.

2

Add several layers of petals behind the two front petals by connecting them at the top with small c-curves. Add a final long c-curve to the outer edge of the flower to create the look of another petal wrapping around the others.

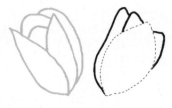

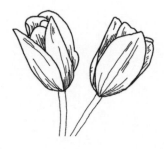

3

4

For the second tulip, start by drawing an oval with pointed ends, similar to the shape of an almond. This tulip will be more of a side view. Next, add two triangular shapes that look similar to cat ears to the top of your oval. Add a final long s-curve to the outer edge of the flower to again create the look of another petal wrapping around the others.

After creating the basic shape of your tulip, add in small lines along the edges of some of your curves to create folds in the petals. To create the illusion that your petals are tightly wrapped around the center of the tulip, draw a series of short and long lines close together near the base of each petal. The lines that are closer together will appear darker and cause the petals to seem as though they are folded or behind each other.

PRACTICE

TULIP

<div style="border:1px solid">1</div>

Start your anemone with a small oval inside a larger oval. This first step of your anemone may resemble sunny-side up eggs, but will soon look more like a flower than your breakfast.

<div style="border:1px solid">2</div>

The center of the anemone is a dense dome that is surrounded by smaller petals or bulbs that hug the center. To draw this, start with a series of short tick marks around the edge of the center circle that you drew in the previous step. Then, fill in the space between the inner circle and the outer circle with small circular shapes.

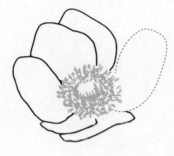

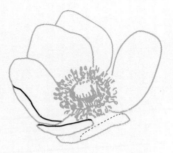

3

Next, draw a series of petals coming from the center of the flower. Start by drawing the two main petals on either side of the center. Then fill in the space between those petals with two or three petals each overlapping and building off of each other.

4

To create the illusion that the petals at the base of the flower are curving up towards the center, add an additional line to the edges of the three petals at the base of your illustration.

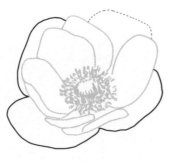

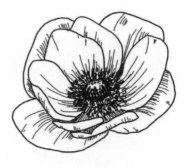

| 5 | 6 |

Now add one more final layer of petals to the outer edge of your illustration. Add four larger petals coming from behind your petals drawn in previous steps. Remember, these petals should vary in shape and length and do not have to be the same!

The three petals that are folding around the base of the flower will have darker shading on the inside of the petal and smaller, lighter shading on the outside of the fold. The curves of the main petals surrounding the center of the flower will be curving up and in, alternating between longer and shorter lines. Finally, the four outer petals that are surrounding the whole flower will have shorter lines that curve outward as the petal folds and curves away from the other petals.

PRACTICE

ANEMONE

SUNFLOWER

THE FLOWER OF HAPPINESS

Draw three circles to start your sunflower illustration. This is the large center full of seeds that a sunflower is known for.

Fill in most of the inner circle with small dots to create a darkened center. You will fill in the two outer circles with some small black dots as well, making the dots closer together and darker the closer you get to the line of the circle. This will create the illusion that the center of the sunflower has three layers to it.

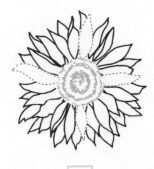

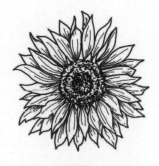

| 3 | 4 |

Now for the petals. The sunflower has lots of petals that are shaped like teardrops. The length of the petals should be about the same length of the circle. Start by drawing one petal at each of the four main quadrants of the flower. Continue to move around the circle, filling in any blank space with petals. When you run out of space, begin filling in some petals that appear to be behind other petals by just drawing the tip of the petal. Some of your petals may be curled or folded.

Once you have added some folds or irregular petals, you can begin to add curved lines to each petal to give it even more shape. Remember to make sure the lines that you draw on each petal follow the curves of that specific petal. To shade the petals, include two or three long lines as well as a few short lines on each petal. Basically, this final step is where you get to add more details to your sunflower to make it appear just the way you want it to!

PRACTICE

SUNFLOWER

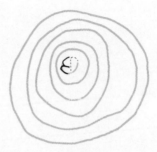

1

Start with six imperfect circles. These six circles will be the basis of your layers of petals. The three layers in the middle should be closer together, while the outer three layers should be a little more spread out. Remember, the more imperfect the better! Draw these in pencil so you can erase them once you have your final illustration.

2

We're going to start by drawing three petals in the center of the flower in our innermost circle. Draw two c-curves that remain open at their base. Draw a third c-curve behind the two petals that you just drew to create a layered look. Remember that the shapes of your petals should not be perfect since your circles are imperfect. Feel free to include some dips and raggedy edges to your petals!

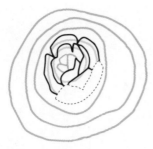

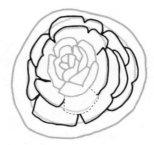

3

4

Next, we are going to fill in the next two circles with a series of s-curves and c-curves to create two more layers of petals. First, create an "anchor petal" at the bottom of your third circle by drawing a long s-curve on top and connecting it with a c-curve on the bottom. Using that "anchor petal," fill in the rest of those two circles with s-curves and c-curves.

The inner three layers of petals are closer together and appear to be hugging the center of the flower. These inner layers are going to act as a base for the next two layers that consist of petals that are more unfolded. Fill in the next two circles with dips and curves that build off of each other, making them larger with each layer.

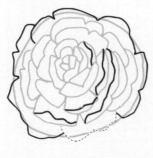

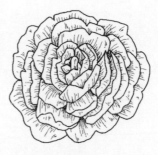

5

Your outermost layer will include your largest curves to reflect the largest petals. Since this is the outermost layer of petals, you don't want your curves to look like a perfect circle. It's okay if you don't follow the circles exactly, and here I encourage you to color outside the lines a little bit! Once you have the basic shape of the peony, add in definition and folds to the petals. Randomly choose a few petals from the top of the flower and several more petals from the bottom of the flower to give more shape. To create the effect of a petal hugging the center of the flower, add in more s-curves and c-curves along the edges of the petals to create more folds.

6

The final step is to add shading. Use small shading lines on the bottom of each petal to give the petals even more definition. Remember, use curved lines that curve with the shape of your petal instead of straight lines. These curved lines will complement the shape of your petal instead of making your petal look flat or cartoonish. You can make your curves longer or shorter depending on the amount of shadow you want to create on that petal.

PRACTICE

PEONY

SWEET PEA

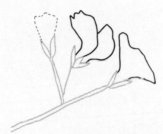

1

The sweet pea grows in small bunches, so start by drawing the main stem of the flower. At the end of this stem, draw two small leaves. From the middle of the main stem, draw two shorter offshoots, again with two or three leaves at each end.

2

Each set of small leaves drawn in the previous step are going to act as the base for the petals. The sweet pea's petals are probably unlike most other petals you've seen here in the book. They have oblong, rugged shapes that perhaps can be described as an unfolding funnel.

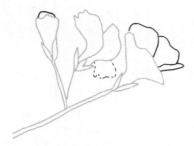

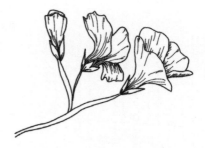

3	4

The petal of the sweet pea is technically one large petal, but you'll be drawing different shapes to show the different sides and dimensions of the petals. In this step, draw a few small details to each bloom to show the petal overlapping or unfolding.

Last but not least, add even more dimension to your sweet pea by adding shading. Near the base of each petal, draw a handful of lines that show the depth of the petal coming out of the small leaves. Also, add lines to the top and middle of the petals, showing the curve and indentations of the edges.

PRACTICE

SWEET PEA

MARIGOLD

THE FLOWER OF CREATIVITY

1

Each marigold has a dome-shaped bulb in its center, so start this flower by drawing a dome-shaped circle in pencil. You will erase this once you are finished drawing the rest of the flower.

2

A dark, dense center is a defining trait of the marigold. Create this trait by filling in your dome with small circles drawn closely together until the center is completely filled.

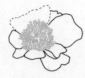

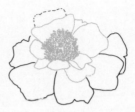

3

Next, draw a ring of petals immediately surrounding the center of your marigold. Start with a few larger petals, and then work your way around the center. These petals are a somewhat boxy shape, but each petal is not always the same size. The marigold is known for its weathered look with jagged edges and an imperfect shape, so feel free to exercise those imperfections here.

4

Continue to draw another layer of petals, remembering to make the petals differ in shape. Add in some dips to the jagged edges of the petals to add to the weathered look of your marigold.

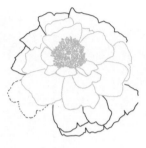

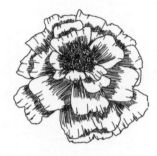

<div style="border: 1px solid; padding: 2px; display: inline-block;">5</div>

Add one final layer of petals to the outer rim of your marigold. You don't have to fill in every space, and you can even add more layers of petals if you want. The more random, rugged and jagged, the better.

<div style="border: 1px solid; padding: 2px; display: inline-block;">6</div>

To finalize the petals, draw a series of tick marks along the each petal at the base closest to the center bulb. This will give depth to your marigold and make it seem as though the petals are layered on top of each other.

PRACTICE

MARIGOLD

LILAC

THE FLOWER OF FIRST LOVE

<div align="center">1</div>

<div align="center">2</div>

Start your lilac by drawing a cone-shaped center with a curved bottom and a pointy top. The lilac itself is actually a bush, shaped like a cone with hundreds of small flowers blooming from the center.

This cone is filled with a multitude of small flowers with four skinny, oval shaped leaves (probably similar to the flowers you used to doodle all over your notes in school). Place several of these flowers randomly inside the cone. You can even draw several budding flowers by drawing small lines coming out from the tip of the cone with two or three small ovals on the edges of the lines.

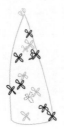

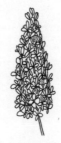

3

4

Continue to randomly place your basic, four-leaved flower shape inside the cone. Remember that none of these flower petals should be perfect or matching.

Continue to randomly fill in the inside of the cone with the smaller four-leaved flowers until the cone is full. Some of these petals may be overlapping or behind other petals. As a final touch, add a small stem coming from the bottom of the cone, erase the cone if it is still visible, and you're done!

PRACTICE

LILAC

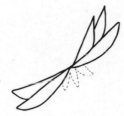

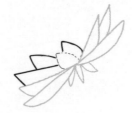

| 1 | 2 |

We are going to be drawing a side angle of the dahlia, so we're going to start it a bit different from the others. Because the main center of the flower will not be visible from this side angle, we are going to start by drawing the three small leaves that are coming off of the base of the flower. These leaves are pointing downward and have a rounded point at the end. The petals of a dahlia create a large cup shape. Draw two or three petals coming out from either side of the base of the flower in a wing-like motion.

Begin to fill in the flower with more petals, making the petals smaller and shorter the closer they get to the center. These petals are all overlapping, so you will not be able to see all of each petal.

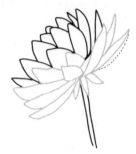

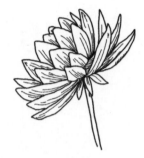

| 3 | 4 |

To finish the main shape of the flower, continue to draw more petals behind the ones you have already drawn by making the petals appear smaller as they get further away from the edge of the flower closest to you. You can also start to add in a few folds to the petals at the base of the flower to show the cradle or cup shape.

To add shape and definition to the dahlia, draw three to five lines along the curves of each of the petals. Alternate between long and short lines, remembering to allow the line to curve in the same direction that the petal would be curving. For the petals that are folding, your shading lines inside the petal will be closer together and point one direction, while the shading lines on the outside of the petal will be further apart and curving in a different direction.

PRACTICE

DAHLIA

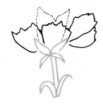

1

2

For the carnation, we're going to start at the bottom and work our way up. First, draw two small leaves at the bottom of the page. Then draw a stem coming from those base leaves. And top it off with four small pointy leaves at the tip of the stem.

From the top of those four small pointy leaves, draw a large bulb shape that appears to be growing out of the leaves with a v-shaped dip at the top. All of the carnation petals will look as though they are coming out of this dip. These petals are boxy with very jagged edges. Start with one or two prominent petals and layer the rest of your petals around those anchor petals.

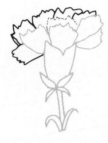

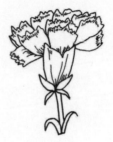

3

4

Continue to add more jagged petals. You can add as many layers as you like, just remember to continue to overlap the petals and include jagged edges and dips along the ends of each petal.

To add definition to the jagged edges of the carnation and the layering of the petals, draw lots of small tick marks on the edges of the petals, following the jagged dips of each petal. Then add some short and medium curved lines to the base of the petals that are overlapping, especially near the main bulb of the flower. Finally, add similar lines to the bulb itself, remembering to follow the curve of the bulb and to make the smaller lines at the base of the bulb closer together to create a darker shading.

PRACTICE

CARNATION

HYDRANGEA

THE FLOWER OF GRATITUDE

1

To start drawing a hydrangea, create a half-dome on your page in pencil. You will want to be able to erase the dome once we have filled it with petals.

2

Next, add a small stem to the straight edge of your dome with a smaller off shooting stem. You are now going to fill the dome with a multitude of smaller flowers. Each small flower will have a tiny circle in the center with four oval shaped petals. The edges of these petals are smooth and round. Draw several large versions of these flowers in your dome.

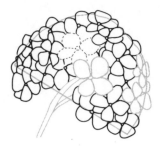

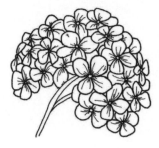

$$3$$

$$4$$

Continue to fill in the dome until it looks full. Create the effect of the flowers overlapping each other by drawing some smaller flowers and some incomplete flowers in the extra blank space in and around your dome.

For shading, add several small tick marks coming from the middle of each petal with a few longer curves that follow the curve of the petal. Erase any of the half-dome that is still visible from step one, and you are done!

PRACTICE

HYDRANGEA

PROTEA

THE FLOWER OF STRENGTH

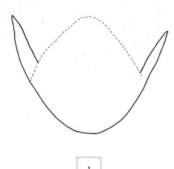

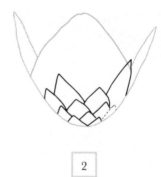

<table>
<tr><td>1</td><td>2</td></tr>
</table>

Start your protea by drawing a large mountain in the center of your page. Then draw a large upside down c-curve that is larger than the mountain. Connect the two main curves of the flower with a pointy petal on each side. All of the petals that you draw later will cradle this dome.

At the bottom of the flower, you will draw pointy petals that resemble scales. These "scale petals" should start off smaller at the base and become slightly larger in size. Fill up the bottom third of the shape with these petals.

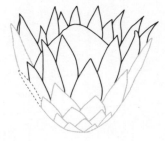

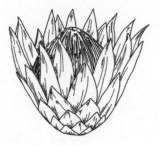

3

Now draw long, pointy petals that cover most but not all of the mountain-shaped center from step one. You may have to erase some of the dome center from behind your petals. To create the illusion that there are petals reaching up from the other side of the flower, you will only draw the tip of the petals peeking out from behind the center dome.

4

To add shadow and depth to the dome shape in the center of the protea, start by drawing a few small dots or circles at the very tip of the mountain dome. Then, fill in the rest of the shape with dark lines that are close together and curved. This will make the middle shape appear to actually be curved or dome-shaped. Finish your illustration off by adding some shading to each petal. Use short lines at the top and bottom of each petal and a few long lines in the middle of the longer petals.

PRACTICE

MAGNOLIA

THE FLOWER OF DIGNITY

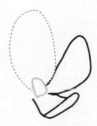

1

Part of the beauty of the magnolia is its beautiful white petals that open and unfold from its center. You'll be drawing a side view of this flower to get the full effect of those unfolding petals. Start with an oval shape that is a little flatter on the bottom as the center of your magnolia.

2

Next, begin drawing the petals by starting with the largest petal coming from the top of the flower. This petal will act as the main petal to center everything else around. Then work your way clockwise around the center, adding several more petals. Add an additional line to the petal at the bottom of the flower to add a fold and show that it is unfolding from the center.

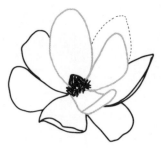

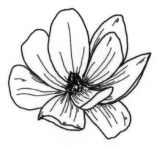

<div style="text-align:center">3</div>

<div style="text-align:center">4</div>

Add another layer of petals to your magnolia by adding a petal behind the petals you drew in the previous step. Then, continue to work your way around the flower clockwise, adding petals of varying shape and size until you reach the main petal from the previous step. Choose a few of these petals near the bottom of the flower to add folds. Once you have all your petals drawn, fill in the center of the flower with short tick marks that are close together to create a dark center. The shading should come to a point at the top of the center and should spread out more towards the bottom.

The final step is the shading of the petals. Each petal should have curved lines of all sizes: short, medium, and long. The longer curves are typical near the center of the petals, the medium curves near the outer edge of the petals, and the shorter curves all along the base of the petals near the center of the flower.

PRACTICE

MAGNOLIA

POPPY

THE FLOWER OF SLEEP

1	2

Start your poppy illustration by drawing a small semicircle with five or six small curves coming from the center. For now, leave the bottom of the semicircle open.

Around the top and bottom of the half circle, randomly place short hair-like lines with tiny ovals at the end. Using different lengths and heights for these hair-like details will add variety and realness to your drawing.

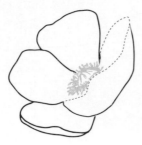

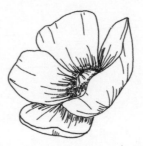

3

4

Next, you will draw the petals. The petals of a poppy are very organic shapes. You are going to draw four petals for our poppy. You'll notice that two of these petals in the front appear to be folding back up towards the center of the flower. Notice the two extra lines added to the petals to show where the petal is folding over.

Add in some detail to the petals by adding a few longer curved lines to the tips of the petals to show their shape. Also, add in some smaller curved lines to the base of the petals closest to the center of the flower to show the shadow and depth of the flower.

PRACTICE

POPPY

ROSE

1

Ah, the rose. One of the most iconic flowers. You can barely see the center of the rose because of how tightly the petals are wrapped around the center. Start with a small c-curve with two tiny c-curves behind it. Then, you are going to draw two larger curves that create a heart shape around the center of the flower. This heart shape creates the illusion that the petals are hugging the center of the rose. This shape does not have to be a perfect heart shape! Finish this step by adding two small downward curves that begin at the top of your drawing and create a small opening on either side of the center.

2

Next, draw three large c-curves around the outer layer of your drawing, making each curve slightly bigger than the previous one. Each curve should build off of the curve right before it to show that the petals are still hugging the center of the flower and slowly unfolding more and more. These curves should remain open at the base of your rose.

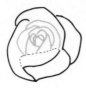

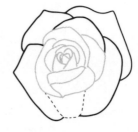

3	4

Close the opening of the previously drawn petals by drawing a rectangular petal at the bottom of your drawing. From that petal, continue to draw several curves that begin at the base and wrap around the center petals. Remember to layer your curves!

Add another layer of petals, starting with a small petal at the very base of the flower. Some petals may be more rounded, but to show that several petals have completely unfolded, bring the middle of those petals to a point.

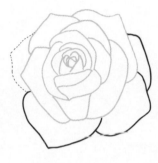

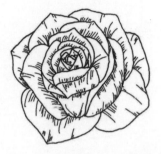

| 5 | 6 |

Add one final layer of petals to your rose until it looks nice and fully bloomed. These petals will be slightly larger than the previous layer and will also have a slight point in the middle of each petal.

To exaggerate the illusion of your petals hugging the center of the flower, add shading to each petal by using curved tick marks along the edges of each petal. Make sure to accent the pointed edges of some petals by drawing shading lines along the point as well.

PRACTICE

ROSE

DOGWOOD

1

You'll start this flower by drawing the basic outline of the dogwood first. To do this, draw a small circle inside a large oval. No need to find something to help you trace a perfect circle or oval. Remember, the more organic and natural, the better!

2

The center of a dogwood is composed of a group of small circles that are very close together. This creates the dark, dense center that is a distinct trait of the dogwood flower.

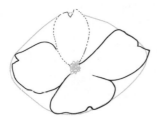

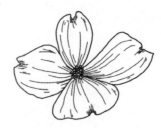

3	4

Next, fill in the oval from the first step with four petals. The petals of a dogwood are somewhat of an oval or oblong shape, but no two petals are alike. Each petal will have a small dip or cleft at the tip (a detail specific to the dogwood), but each petal should look a little different than the one beside it.

To give the petals shape and definition, add curved lines to each end of the petals. The lines towards the edge of the petal will be shorter and closer together near the dip. The lines towards the center of the flower will be a variety of lengths. Then randomly place a few longer lines throughout each petal, remembering to curve the line to match the curve of the petal.

PRACTICE

DOGWOOD

CAMELLIA

THE FLOWER OF PERFECTION

1

The center of a camellia starts with three small buds. These buds are similar to the shape of a balloon, rounder on one end and coming together to a point at the other end.

2

In the next few steps, you'll be filling in the rest of the flower with c-curves or loops to create petals that all build off of each other. It is usually easiest to start with an anchor petal near the top and then work your way around the flower clockwise.

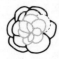

3	4

Make another layer of petals, starting with one main anchor petal near the top and working your way around the flower. Some petals will appear to be behind others to add to the layered look. The edges of these petals are more rounded and smoother than the petals of a peony or a ranunculus, but they are still not perfectly rounded.

Continue to go around the circle of petals, adding c-curves to each layer. Each layer should be organic because there is not a certain number of petals on each layer. The layers towards the center will be closer together, and each layer of petals will get slightly bigger as they get further away from the center.

<div style="text-align:center">5</div>

Feel free to continue to add layers until your flower is the size you want it to be. Once you feel like your camellia is finished, your final layer of petals will close off the gaps between petals with smaller petals to create the illusion that those outermost petals are tucked behind all the others.

<div style="text-align:center">6</div>

Because of all the layers of the camellia, the shading of the petals is important to really show the bends and curves of the flower. Each petal will need a series of small lines and curves that start from the center of the flower. Remember to curve the lines in whatever direction you want your petals to curve. Also, remember to draw the lines closer together wherever you want to create more shadow, particularly where the petals are overlapping.

PRACTICE

CAMELLIA

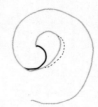

| 1 | 2 |

The gardenia might be the most difficult flower you'll learn how to draw in this book. Therefore, it's going to have a few more steps than the previous flowers you've drawn. Start your gardenia by drawing a large swirl in the middle of your page.

Next, add a few small details to the center of the swirl by adding a small fold to the center of the flower and closing off the center of the swirl by connecting the point in the middle to the adjacent line with a backward c-curve.

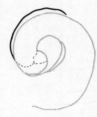

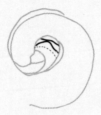

| 3 | 4 |

You're going to continue to add small details to the center in the next few steps. In this step, you'll be adding another connecting point from the center of the swirl to the adjacent curve by connecting the two points with a curvy 'y' shape. Then add an additional fold to the outer edge of the swirl.

Add three small curvy or squiggly lines to the very center of your swirl. These are three small petals that appear in the very middle of the flower. Right now your sketch may look like a sea shell or a snail, but in just a few more steps it will be beautiful!

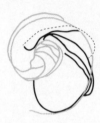

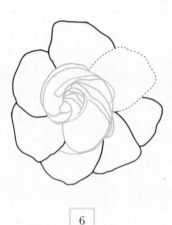

| 5 | 6 |

This may be the most difficult step of the gardenia, but don't quit! You're basically going to be adding several petals and folds that follow the edge of the swirl that you created in step one. Start from the top and work your way down by drawing a petal and then adding a fold. Do this again, drawing a petal from the center to the outer edge of the swirl, and then adding a fold. End by drawing one large petal that starts at the center and goes along the edge of the swirl before closing the opening of the swirl.

Now for an easy step! To add the petals of the gardenia, start with the main anchor petal near the top of the flower, and add your petals moving in a clockwise direction around the center. Try to make your petals curve in the same direction as the center swirl by making them lean slightly the right.

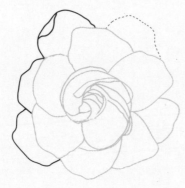

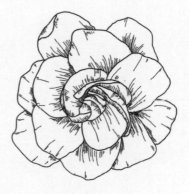

7

8

Add a few more petals to the outer edge of your gardenia. Add extra lines to the edges of a few of your petals to create folds. You can add however many petals and folds you like!

The last step is to add your shading. Your shading near the center will include shorter lines that are closer together, creating a darker shadow on those inner curves and folds. Add some shading lines on both the inner and outer edges of each petal. Remember to use a variety of line lengths and to curve the lines to match the curve of the petal.

PRACTICE

GARDENIA

RANUNCULUS

1

The ranunculus has lots and lots of petals. These petals start small in the center and get a little larger as you get further from the center. Start the center with a small figure-8 shape or an infinity sign.

2

From the center that you created in the previous step, start adding petals by going around the center in a clockwise motion. Wiggle your pen as you go around the circle, making each petal its own imperfect shape. Finish this step with a layer of four petals that are a little boxier than the petals closest to the center.

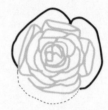

3

Next, we're going to add a special detail to the four outer petals that you drew in the previous step. Add an extra line to the edge of each of those boxier petals to create folds. The folds on this layer make the center section look like it is curling in around the center of the flower.

4

The rest of the petals are going to be a little bigger and longer since they are larger and more open than the newer, younger petals towards the center. Add three or four larger petals to this layer.

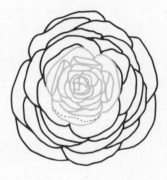

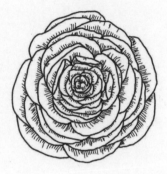

5

Finish filling out the flower with these petals until it is the size that your want. Remember that the petals do not all have to be the same size, but instead should be random and organic and imperfect.

6

Along the base of each flower, add short tick marks close together to give depth and definition to the many petals of your ranunculus.

PRACTICE

RANUNCULUS

WILDFLOWERS

There are such things as wildflowers, but for this book (and for me personally) I don't want to put wildflowers into specifics. I want them to be wild! These are really just fun filler flowers that I draw all the time when doodling or illustrating arrangements. So don't worry about where to start or what kind of flower you are drawing. Instead, just use the skills we have been practicing and draw whatever comes to your mind. Let your mind and your flowers run wild on the next page!

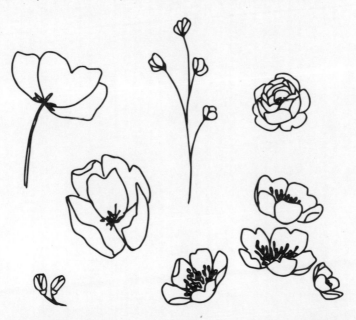

PRACTICE

WILDFLOWERS

<div align="center">

1

</div>

This wouldn't be a book by Alli without a cactus or two...or three! There are over 1,000 different species of cacti, and this book is going to give you a glimpse of three of those, starting with the prickly pear cactus. To begin, draw two main globe-shaped "pads" that are going to act as the base for the rest of the cactus. These pads will build off of each other in the next step.

<div align="center">

2

</div>

Next, add a second level of globe shaped pads coming out from the base. Your pads should appear to be coming out of the base in three main branches.

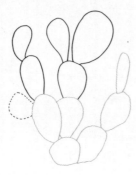

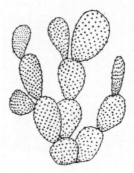

<div style="text-align:center">3</div>

Continue adding those globe-shaped pads to the three main branches from the previous step. Each branch will be different, some with only one pad growing off of it while others may have two. Remember that each pad doesn't have to be the exact same shape. Some may resemble a more circular globe shape and some may look more like a teardrop.

<div style="text-align:center">4</div>

Now it's time to add the prickles! From far away, these prickles look like small polka dots, therefore giving this cactus the nickname "polka dot cactus." So to create these prickles, simply make small circles using imperfect, squiggly lines to add to the appearance that these circles are protruding off the surface of the cactus.

PRACTICE

CACTUS

CACTUS

SAGUARO

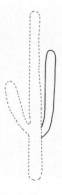

| 1 | 2 |

This is the cactus most people picture when they hear the word "cactus." With a pencil, start by drawing the basic outline of this cactus with three main stalks or stems. The middle stem will be straight, while the outer two will start at different parts near the base of the middle stem and curve outward and upward. It is important that you do this step in pencil because you will be adjusting the shape of the stems in the next steps, making the shape more three-dimensional instead of flat.

Using your pen, retrace the main branch of your cactus, making it more imperfect than the shape of your outline. Also, retrace your branch on the right, also making it more imperfect than the shape of your outline. This time, bring the base of the branch onto the middle branch and close the bottom off.

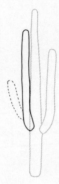

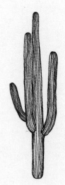

3

Next, retrace the small branch on the left side of your cactus, again giving it a more imperfect definition than the shape of your outline. Then, if you want to take this cactus one step further, add a new branch that somewhat reflects the branch you adjusted in the previous step. Adding additional branches will help make your cactus look more three-dimensional.

4

The final step is to add shading to your cactus. The cactus is somewhat ribbed or pleated, so your shading will show that. Rather than short tick marks like you've used on the other flowers in this book, your shading here will be long lines that stretch the whole length of each branch. These lines will be mostly straight but will curve at the very tip and the base of the branches.

PRACTICE

CACTUS

CACTUS

PRICKLY PEAR PAD

1

The first step of this cactus may look like you are drawing the face of an alien, but the shape is the same! Start with an oval shape that is slightly smaller at the bottom and wider at the top. Don't worry about making the oval perfectly smooth. The more imperfect the better!

2

There is a small flower that is budding from the top of this cactus. To draw this, add a small bud to the top of the oval that you drew in the previous step. The top of the bud will be slightly slanted towards the left to portray more of a side view of the flower in the next step.

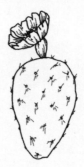

| 3 | | 4 |

Next, add the petals of the flower. You may want to start by drawing a large, upside down c-curve that tilts to the left that will act as the base of the petals. Then add in petals along that curve that have a small dip at the edge of each petal. Add another row of petals that are slightly bigger that will show the other side of the flower, again including a small dip at the edge of the petals. You may also want to add in a few folds to the petals on the left and right of the flower to show the curve of those petals, as well as adding some dots to create depth in the center of the flower.

Finish this cactus by shading the flower bloom by adding lines to both the petals and the stem of the bud that connect the bloom to the large oval. Remember to use a variety of short and long shading lines and to curve them in the direction that the pad is curving. Finally, add what makes a cactus a cactus... spines! Add these prickly spines or thorns by squiggling a few really loose circles with one main v-shaped spine coming out of the top or side. Then underneath, add a few lines that vary in length to add a little shadow and depth.

PRACTICE

CACTUS

SUCCULENT

ECHEVERIA

Succulents come in all shapes and sizes, so you'll get to see two different illustrations of succulents here in this book! You'll start by drawing the center of the succulent, just like the other flowers you've been practicing. The center of this succulent starts with a small triangle surrounded by a circle. The circle should come close to touching two of the three corners of the triangle, leaving a small space between the bottom point of the triangle and the edge of the circle.

Next, add what looks like the capital letter 'A' to the center of the triangle. This small detail adds depth to the center of your succulent. Also, add a small line connecting the bottom point of the triangle to the edge of the circle. Now it's time to start adding the "petals" of the succulent. This first layer of petals may be more rounded at the edges, but most succulent petals will come to a small point in the middle. Start with three petals for your first layer.

HOW TO DRAW MODERN FLORALS

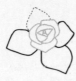

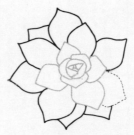

| 3 | 4 |

For your next layer of petals, add four petals near each of the four main quadrants of your succulent. These petals should come to a slight point at the ends, but they should not all be exactly the same! Make some petals small, or even overlap some of them.

Add another layer of pointy petals to your succulent. It's best to start with an anchor petal and work your way clockwise around your drawing. Each layer doesn't have to have the same amount of petals, and each petal doesn't have to be the same. You may not be able to see every single petal, so add a few that are peeking from behind other petals.

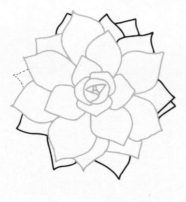 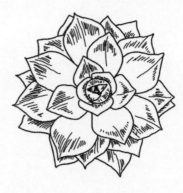

<table>
<tr><td>5</td><td>6</td></tr>
</table>

5

Add a few more petals until you feel like your succulent is complete. Be sure to make some of these outer petals overlap each other to show the depth and fullness of the plant.

6

Now for the shading! For the very center of the succulent, draw several rows of short tick marks close together to make the center a little darker than the rest of the plant. For each of the petals that are fully visible, draw a prominent longer line from the point of the petal and draw some lines to either side that progressively decrease in length. You may not be able to do this on the petals that are hiding behind others, but still be sure to include some shading lines on those petals as well, especially near the base that is tucked behind another petal.

PRACTICE

SUCCULENT

SUCCULENT

ZEBRA CACTUS

1

This type of succulent is very pointy, so get ready to make lots of triangles instead of curves this time. Start your succulent with two diamonds side by side. Your diamonds will share one of their sides. This is going to act as the center of your succulent around which everything else will be unfolding.

2

This next step looks like one of those fortune tellers kids used to make in elementary school by folding paper. On either side of your two center diamonds, make two larger triangles that are slightly bigger than the diamonds and slant outward away from the center. Now connect those triangles to the diamonds by drawing a small line that connects the point of the triangle to the back of the diamonds. Draw one more large triangle to the left of your succulent, connecting it on the left with two lines that are closer together and one line on the right that wraps around the diamonds.

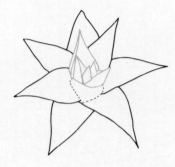

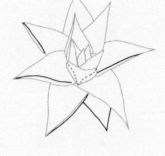

3

The rest of your "petals" will be a bit larger and will appear as though they are unfolding and laying somewhat flat. Start with the petal at the base of what you drew in the previous step. From there, continue to draw more triangles from the center of the flower and include folds in several of the triangular "petals."

4

Next, add some additional lines to the petals that you drew in the previous step to give them more of a three-dimensional shape. Start with a smaller triangle inside the petal that is pointing downward coming from the base of your drawing. Then choose several petals from the lower half of your drawing to add folds to by adding an additional line to one edge of the petal.

| 5 | 6 |

To continue to add depth and dimension to this succulent, add one final layer of triangular petals that appear to be behind the others. Add as many or as few as your like, and also add a fold or two to some of those petals that are tucked behind the others.

The final step for this succulent is to add in the shading. Start by drawing a line down the center of each triangle. Some of these lines will be straight, while others may curve to show that the "petal" is curving towards the center. Then, on either side of the lines that you just drew down the center, add horizontal lines. These lines should not be completely straight, and instead should be a bit jagged or crooked. You'll also want to partially fill in your folds with smaller lines that are closer together to add a darker shading.

PRACTICE

SUCCULENT

FLOWERS AT AN ANGLE

Now that you've practiced drawing a basic form of all of these flowers, I wanted to give you another element to consider. While each type of flower is drawn differently from the rest, each individual flower can also be drawn differently. You can draw every flower from a different angle, whether you're looking at the flower straight forward, from above, or from a side view. You can also draw every flower at different stages of bloom, whether the flower has fully blossomed or is still a developing bud. The point is, you now have the skills to start drawing any type of flower from any angle you like! The steps and lines will be the same, but with slight variations. Try visiting your local florists and using some real flowers to help you visualize which angle you want to draw.

PEONY

POPPY

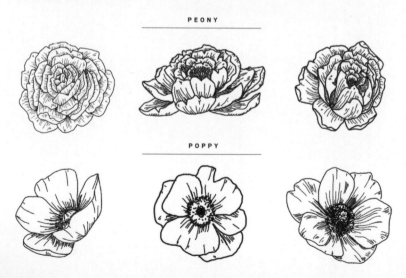

DAHLIA

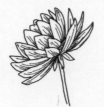 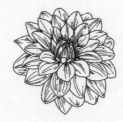

ROSE

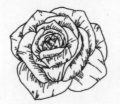 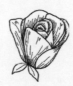

CARNATION

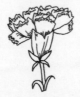 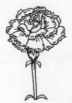

PRACTICE

MAKES BETTER

LEAVES

Once you feel comfortable sketching the flower itself, you can get creative and add stems and leaves to your blooms. Leaves can be as simple or as complex as you want them to be. The basic shape of a leaf (pictured below on the left) is simply two c-curves put together. When adding leaves to a stem, you will simply add another c-curve that attaches the leaves to the stem (pictured below on the right).

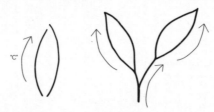

If you're really feeling creative, you can add bends and folds to the leaves to reflect their actual shape in real life. Below are some examples of this. Your leaves may be folded over completely, bending away from the flower, or wrapped up tightly.

There are just as many different types of leaves as there are different types of flowers. Just like we couldn't cover every single flower in this book, we also couldn't cover every single leaf either. On the next page are just a few examples of the variety of leaves for you to add to your illustrations!

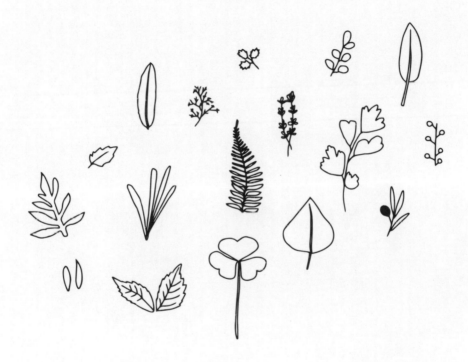

Adding a mixture of thick and thin lines, as well as different patterns, helps give leaves character and shape. You can show curves and bends in the leaf by adding shade lines to the long middle line of the leaf. All of your other shading lines will build off of this long middle "base" line.

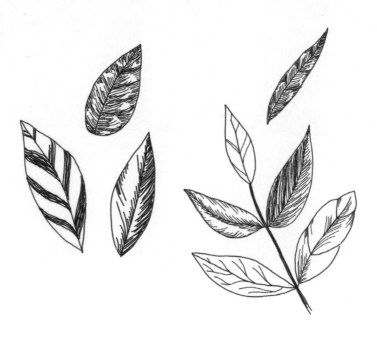

PRACTICE

LEAVES

ARRANGEMENTS

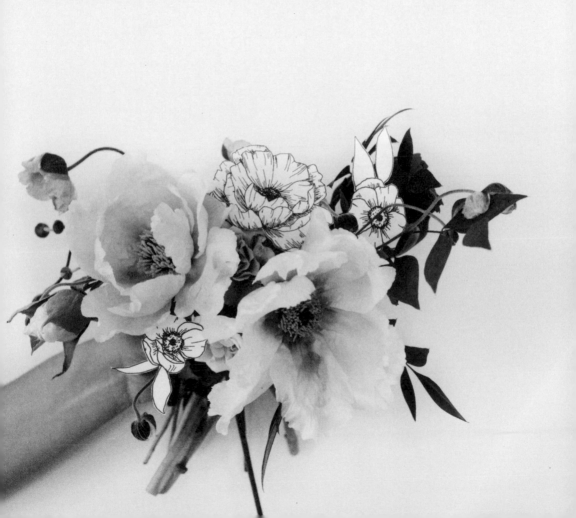

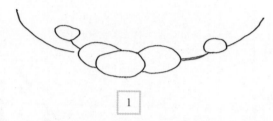

1

To create a floral wreath, start with a basic outline that includes your basic shape and a general idea of where you will be placing your main blooms.

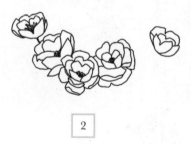

2

Now fill in the main flower blooms. Try to imagine what angle you will be seeing of each bloom.

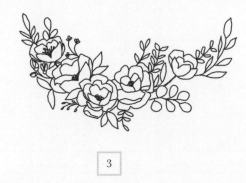

3

Next, draw some leaves coming off of your main flowers. You'll be want to start in the middle of the wreath and work your way out to the edges.

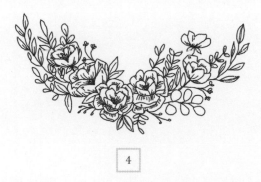

4

Finally, fill in the extra space with smaller leaves or filler flowers and add in shading.

PRACTICE

WREATH

BOUQUET

1

To create a bouquet, with a pencil, start with a basic outline that includes your basic shape and a general idea of where you will be placing your main blooms.

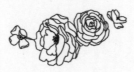

2

Now fill in the main flower blooms. Try to imagine what angle you will be seeing of each bloom.

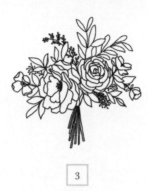

3

Next, draw some leaves or filler flowers coming off of your main flowers. Also, add more definition to your stems at the bottom of your bouquet.

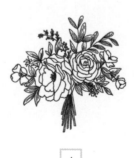

4

Finally, add in shading to your leaves to give your whole bouquet some more shape and definition.

PRACTICE

BOUQUET